A Renoir

THE LIFE AND WORKS OF
RENOIR
Janice Anderson

A Compilation of Works from the
BRIDGEMAN ART LIBRARY

PARRAGON

Renoir

This edition first published in Great Britain in 1994
by Parragon Book Service Limited

© 1994 Parragon Book Service Limited

ISBN 1 85813 536 2

Printed in Italy

Designer: Robert Mathias

Auguste Renoir 1841-1919

Although Pierre Auguste Renoir was one of the founders of Impressionism and a revolutionary among painters, his real ambition, which he did not discover until 1881 when he visited Italy, was to be an artist in the grand Renaissance tradition of Titian. Until he went to Italy, his painting was decorative in style, with a delicate sense of colour he had developed while an apprentice porcelain painter.

Renoir was born in Limoges on 25 February 1841. His father was a tailor who moved to Paris, where the 14-year-old Renoir was apprenticed to a firm of porcelain painters. His natural talent for colour was given a new direction when he passed the Ecole des Beaux- Arts entrance exam and joined Charles Gleyre's studio, where he met many young artists who would later be labelled Impressionists.

The early work of these young painters was derided by the art establishment of Paris and refused entry to the official Salon. To make a living, Renoir painted conventional portraits but also exhibited his Salon rejects at the Salon des Refusés.

At Gleyre's studio, Renoir had become a good friend of Claude Monet and they began to paint together, notably at Argenteuil, near Paris, where Monet had a house which became a meeting-place for young painters.

In 1874, tiring of the Salon's rejections, several young painters, including Renoir, Monet, Sisley and Berthe

Morisot, organised an exhibition of their own. Renoir included seven paintings in this exhibition, which was not a financial success but which did get the painters their name, 'Impressionist', at first given them as a term of derision.

At the second Impressionist Exhibition in 1876 Renoir showed 15 works. At this period he was becoming increasingly successful , with his painting of *Madame Charpentier and Her Children* achieving a notable success in the 1879 Salon.

Then came his visit to Italy in 1881. He was so overwhelmed by the work of the Italian Renaissance painters, whom he encountered for the first time, that he decided he knew nothing about drawing and very little about paint. From now on, he would tighten his line and gradually give up the Impressionist way of applying paint in small strokes of colour, using instead the traditional method of putting it on in layers and glazes.

A visit to Cézanne at L'Estaque near Marseille on his way home from Italy confirmed him in his new approach, for Cézanne had broken away from Impressionism to develop a severe structural style of his own. Renoir now concentrated on developing his own new techniques. His *Umbrellas,* painted over several years in the early 1880s, was a formal composition full of the planes of colour and tight structure of a Cézanne painting.

Realizing that tight drawing and rich colour were incompatible, Renoir concentrated on combining what he had learned about colour during his Impressionist years with traditional methods of applying the paint. The result was a series of masterpieces very much in the tradition of Titian, as well as Fragonard and Boucher, whom he admired. There was much critical praise for the work

Renoir included in a one-man show of 70 organized by the dealer Paul Durand-Ruel, and his first official recognition came when the French state bought *At the Piano* in 1892.

In 1885 a son, Pierre, had been born to Renoir and his long-time mistress and model, Aline Charigot. Three years later, visiting Cézanne at Aix-en-Provence, Renoir discovered Cagnes which became his winter home when he began suffering from arthritis and rheumatism. He spent long periods in the south with Aline, now his wife, adding two more boys to his family: Jean, born in 1894, who was to become one of France's greatest film directors, and Claude (Coco) born in 1901. The house at Cagnes, Les Collettes, which the Renoirs built in 1907, was to become an important haven for work and home life.

As Renoir's arthritis worsened, he found it increasing difficult to hold his brushes and eventually had to have them strapped to his hands. He also took up sculpture, in the hope that he could express his creativity through modelling, but even in this he needed help, which came from two young artists, Richard Gieino and Louis Morel, who worked under his instructions.

Despite his severe physical disabilities, Renoir continued working up to the last year of his life. His great canvas in the Louvre, *The Bathers*, was completed in 1918. In 1917, he was visited by a young painter called Henri Matisse, who was destined to carry forward his ideas of colour into a new era. Renoir died at Cagnes on 3 December 1919. He was 78 and recognized as one of the greatest of French painters.

▷ **Alfred Sisley and His Wife** 1868

Oil on canvas

ALFRED SISLEY was among the Impressionists who gathered round Monet and Renoir at Argenteuil. He was a quiet, rather reserved Englishman who, on the whole, preferred to work in solitude rather than in an artistic milieu. Perhaps he was rather overwhelmed by the gallic exuberance of his fellow painters, although he certainly shared their ideas and was a good friend of both Monet and Renoir. Renoir's painting of the newly-married Sisley and his wife, Marie, was probably done during an outing to the Forest of Fontainebleau in 1868. It reveals the talent for portraiture which earned Renoir his keep while he was developing the techniques which would make him a master painter, and it also shows him at home with the Impressionists' insistence on painting portraits of people in naturalistic and even unconventional attitudes.

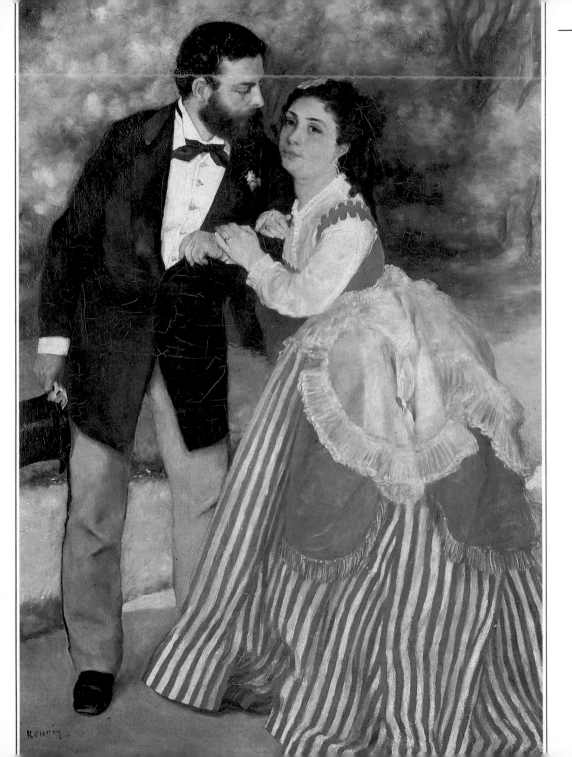

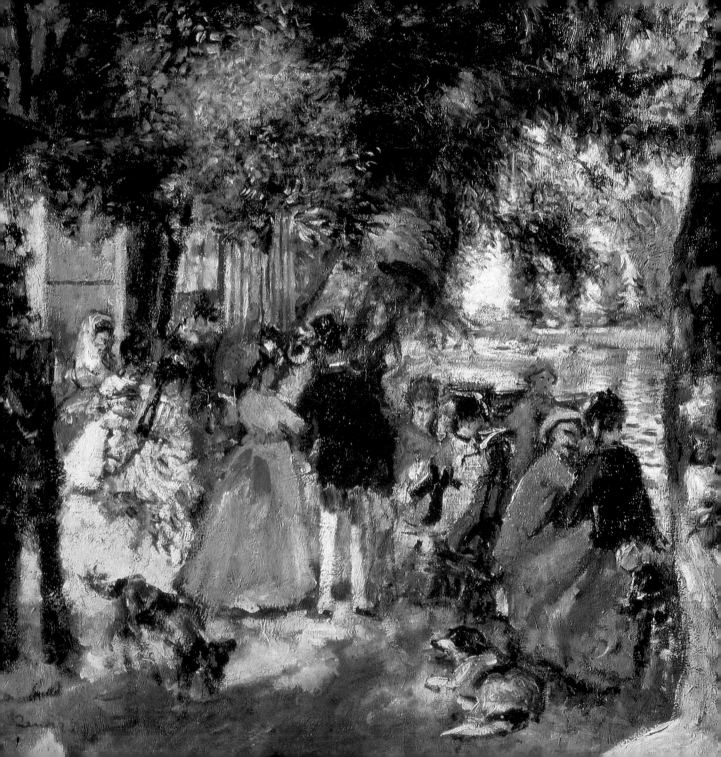